Using Calligraphy

LAYOUT & DESIGN IDEAS

ALAN FURBER

 Sterling Publishing Co., Inc. New York

Library of Congress Cataloging-in-Publication Data

Furber, Alan.
 Using calligraphy: layout & design ideas/Alan Furber.
 p. cm.
 Includes index.
 ISBN 0-8069-8428-7
 1. Calligraphy. 2. Graphic arts. I. Title.
Z43. F97 1992
745. 61 -- dc 20 91-39932
 CIP

Jenny Joseph. An extract from "Warning" published
by Bloodaxe Books, 1992

10 9 8 7 6 5 4 3

Published by Sterling Publishing Company, Inc.
387 Park Avenue South, New York, N.Y. 10016
© 1992 by Alan Furber
Distributed in Canada by Sterling Publishing
c/o Canadian Manda Group, P.O. Box 920, Station U
Toronto, Ontario, Canada M8Z 5P9
Distributed in Great Britain and Europe by Cassell PLC
Villiers House, 41/47 Strand, London WC2N 5JE, England
Distributed in Australia by Capricorn Link Ltd.
P.O. Box 665, Lane Cove, NSW 2066

Sterling ISBN 0-8069-8428-7

for

Victoria and Paul

with continuing love,
amusement and delight

Acknowledgments

My heartfelt thanks to:

"Chad" Kean who helped me decifer Alan's filing system
so we were able to gather together and organize the
pieces of his work.

Debra Cantoni-Sementelli who added the finishing
calligraphic touches to the book including the index,
acknowledgments, dedication and copyright pages, and
corrected any grammatical errors in the text.

John Woodside, Alan's editor, who was always there
to keep me firmly on the yellow brick road.

 — Areté Furber

A special note of thanks to Connie "Chad" Kean,
for her unstinting cooperation in the preparation
of this book and in particular the section dealing
with certificate design.

 — Alan Furber

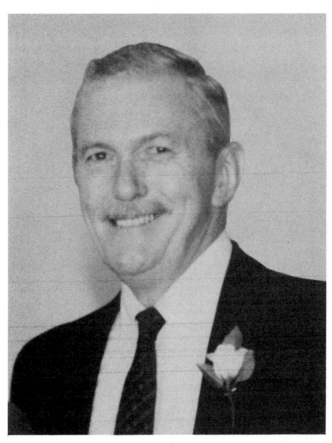

Photograph by Ray Bryant

Alan Furber grew up in Milton, Massachusetts, and fell in love with calligraphy while in art school. It was a love affair that lasted a lifetime. Over the next 40 years he moved to Texas, opened a successful graphic design and calligraphy studio, co-founded Kaligrafos, the Dallas Calligraphy Society, and became a nationally recognized expert in the field, teaching calligraphy classes and workshops across the country. He once told an interviewer, "I don't have any hobbies, because if I did, I'd just end up doing what I'm doing." Alan Furber's first book , Layout and Design for Calligraphers, is a widely used text for professionals and beginners alike.

Contents

Preface

Since the publication in 1984 of the unique and successful <u>Layout and Design for Calligraphers</u>, many readers have asked that a second collection of layout ideas be made available for additional study and practice.

This book is intended as a set of guideposts only, providing a stimulus to create your own designs, your own individual style.

Once you have studied these examples, you can then go on to experiment with different surfaces, materials and lettering techniques.

You may even experience a sort of "design osmosis," which occurs as you do more and more layouts. An idea which may turn out to be inappropriate for a certificate, for instance, may work much better on a poster or an envelope.

Introduction

"One for the money,
Two for the show..."

This familiar chant sums up the major difference
between designing commercial work (for the
money) and creating art solely for our own
enjoyment (for the show).

Designing a piece of calligraphy for which we
are paid requires that our layouts must follow
specific guidelines set by someone else (a client).

But when we create art for ourselves, e.g. decor-
ating an envelope, we are more free to take design
chances, aware that if it doesn't work, we've
lost only time, not a customer.

The information and layout ideas which follow
deal with assignments common to most of us.
Happily, these same suggestions apply equally as
well to designing other types of jobs, such as
newsletters, scrolls, keepsakes, calendars — what-
ever comes across our drawing boards.

Layouts

The problem with other graphic design manuals is their indifference to the needs of the beginner. How did the artist arrive at those beautiful 4-color designs from a blank sheet of white paper? No explanation is ever given.

To address this omission, here are some ideas and examples of how layout solutions can evolve.

The first step is to begin sketching ideas. These "thumbnails" are usually done in pencil, allowing our ideas to flow freely onto the paper. At this point, we're not concerned with lettering words carefully or other details. Those come later. Initially, we're using a rapid graphic shorthand, exploring idea after idea. We're trying out combinations of line and mass, of light and dark, using each thumbnail as a springboard to the next.

Layouts

Even at this stage, remember that to be successful,
a design must

 1) be visually balanced, not
 overweighted on one side

 2) employ an interesting use of
 contrast through changes in
 size, color, position, etc.

 3) include a single dominant
 element, allowing the eye
 a place to enter the design

A composition can have plenty of contrast, yet lack any
dominance, but a single dominant element will
automatically create contrast. (All robins are birds,
but not all birds are robins.)

It may be awkward at first, learning to loosen up
and keep your thumbnails sketchy, but with
practice, you'll soon acquire the knack.

Layouts

This is the day which the Lord hath made;
we will rejoice and be glad in it.
(Psalms 118:24)

There are several ways in which this
Biblical quote can be arranged: in a
formal, symmetrical composition—

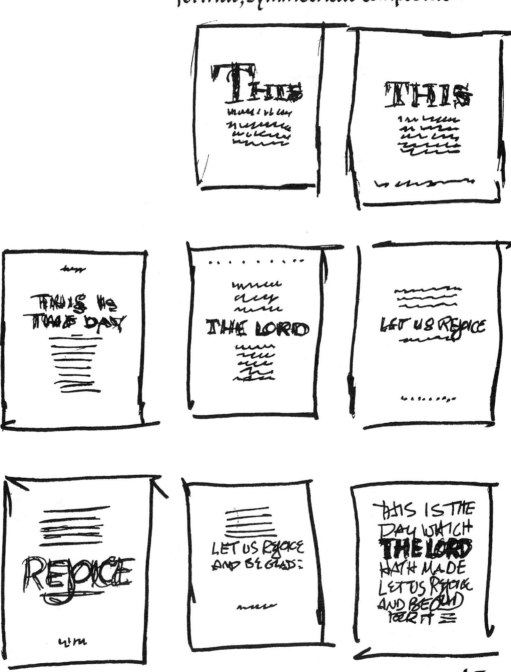

Layouts

—as well as an informal, more casual
layout, reflecting the affirmative message
contained in the words.

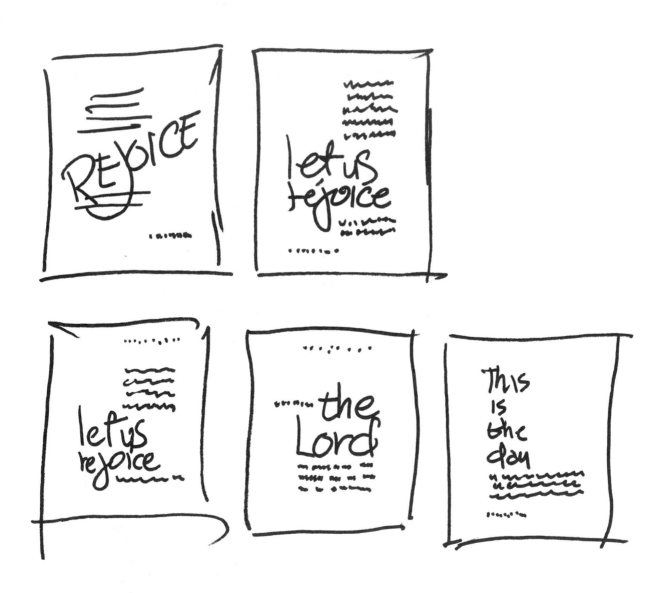

Layouts

Stressing words from the quotation itself
is not the only option we have.

Once a layout has been selected,
we can begin lettering the dominant
element, selecting a style . . .

Layouts

. . . and then fitting the text around
the major element.

This is
the day
which
the Lord
hath made;

let us
rejoice

and be glad
in it.

P S A L M S 1 1 8 : 2 4

The assignment is to completely redesign an existing certificate.

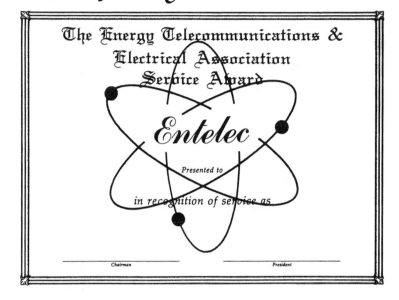

Before beginning the thumbnails, what are some of the characteristics of the present award which can be improved?

1. There is no differentiation between the title of the organization and the words "Service Award."

2. The logo obscures some of the copy and clutters the area allowed for the filling-in of name and service.

3. No provision is made for adding the date.

4. Signature lines are too close to the bottom margin.

19

Layouts

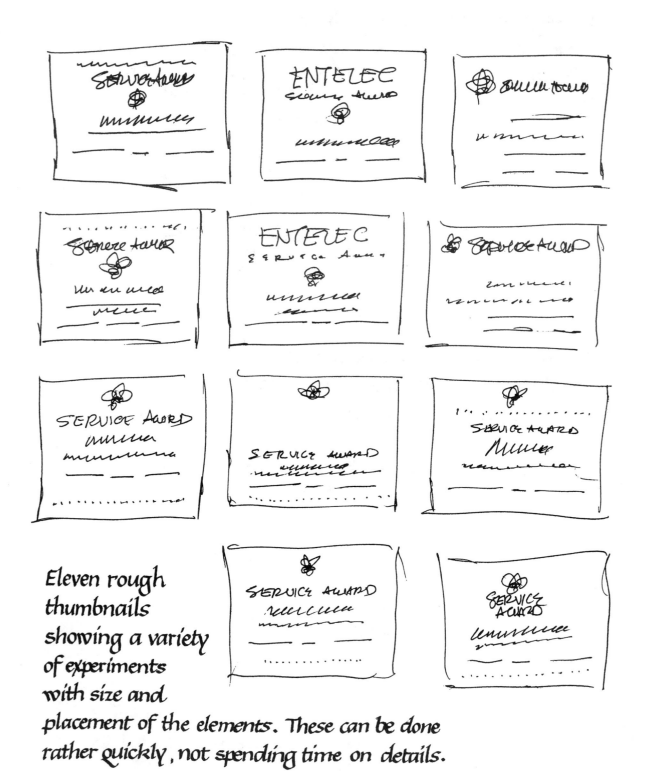

Eleven rough thumbnails showing a variety of experiments with size and placement of the elements. These can be done rather quickly, not spending time on details.

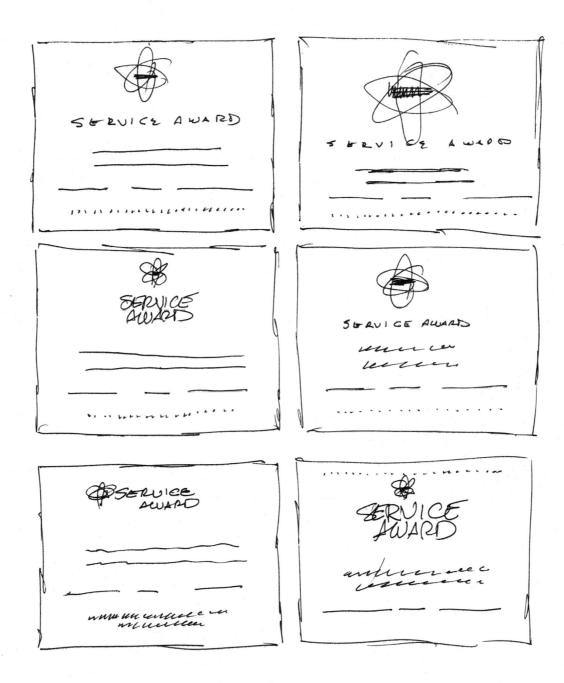

These sketches are more specific, alternating dominance between the logo and "Service Award."

Layouts

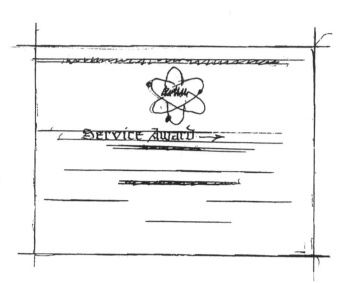

Decided to make the
logo dominant. A mistake.

Notice that although
the logo is larger, it's
too light to dominate
and would need to be
enormous in size. An
example of how rough
sketches can mislead.

Solution: beef up the
words instead.

The Energy Telecommunications & Electrical Association

Service Award
presented to

in recognition of service as

When the certificate was enlarged back up to
8½ X 11, "Service Award" was too strong, too dark.
By inlining the letters, the weight of the title
was lightened satisfactorily.

The Energy Telecommunications & Electrical Association

Entelec

Service Award

presented to

in recognition of service as

Layouts

*After all of that work, the customer went "in house"
to design the certificate.*

THE ENERGY TELECOMMUNICATIONS &
ELECTRICAL ASSOCIATION

SERVICE AWARD

Presented to

in recognition of participation in the

ENTELEC TECHNICAL PROGRAM

_____ _____
Chairman President

Layouts

A balloonist friend wanted a flyer (no pun intended) for local distribution, emphasizing the festive aspect of the offer.

The flyer was to promote balloon flights, so they were selected to be the dominant element within an informal layout.

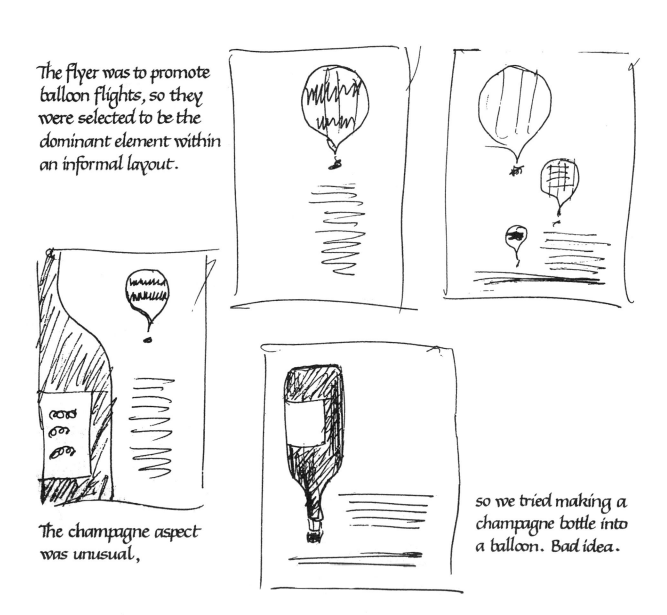

The champagne aspect was unusual,

so we tried making a champagne bottle into a balloon. Bad idea.

Layouts

Then placing a champagne bottle onto the balloon. Looked like an advertising stunt.

Tilting the glass to contrast with the vertical format, and stacking the text to imply an upward-drifting movement.

Adding streamers to heighten the party motif.

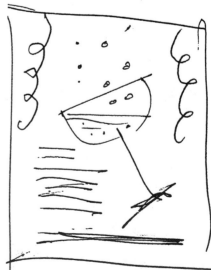

While drawing the bubbles, one of them looked like a tiny balloon...Eureka!

Treat your loved one to a Champagne **BALLOON FLIGHT** ($250. PER COUPLE)

Now booking through Center Line Aviation at Addison Field – Phone: 453-9206

FOR OTHER COMMERCIAL OR ADVERTISING USES, CALL 238-8838

Layouts

This quote was penned for distribution
at a Chamber of Commerce luncheon.

PRESS ON
Nothing in the world can take the place of persistence. Talent
will not; nothing is more common than unsuccessful individuals
with talent. Genius will not; unrewarded genius is almost a
proverb. Education will not; the world is full of educated dere-
licts. Persistence and determination alone are omnipotent.

PRESS ON

Nothing in the world can take the
place of persistence.
Talent will not; nothing is more
common than unsuccessful individuals
with talent.
Genius will not; unrewarded genius
is almost a proverb.
Education will not; the world
is full of educated derelicts.
Persistence and determination
alone are omnipotent.

The first attempt used
a formal layout.

Beefing up the title
improved the contrast
yet lacked interest.

PRESS ON

Nothing in the world can take the
place of persistence.
Talent will not; nothing is more
common than unsuccessful individuals
with talent.
Genius will not; unrewarded genius
is almost a proverb.
Education will not; the world
is full of educated derelicts.
Persistence and determination
alone are omnipotent.

PRESS ON

Nothing in the world can take the place of persistence.
Talent will not; nothing is more common than unsuccessful individuals with talent.
Genius will not; unrewarded genius is almost a proverb.
Education will not; the world is full of educated derelicts.
Persistence and determination alone are omnipotent.

Switching to an informal format adds some life to the piece.

PRESS ON

Nothing in the world can take the place of persistence.
Talent will not; nothing is more common than unsuccessful individuals with talent.
Genius will not; unrewarded genius is almost a proverb.
Education will not; the world is full of educated derelicts.
Persistence and determination alone are omnipotent.

An example of extreme dominance.

Layouts

The father who received this sentiment from his 15-year-old daughter was deeply touched.

```
DADDY
4 Years--"My Daddy can do anything."
7 Years--"My Daddy can do a lot--a whole lot."
8 Years--"My Daddy doesn't know quite everything."
12 Years--"Oh, well, naturally Father doesn't know that either."
14 Years--"Father? Hopelessly old-fashioned."
21 Years--"Oh, that man is out of date.  What did you expect?"
25 Years--"He knows a little bit about it, but not much."
30 Years--"Must find out what Dad thinks about it."
35 Years--"A little patience: let's get Dad's opinion first."
50 Years--"What would Dad have thought about that?"
60 Years--"My Dad knew literally everything."
65 Years--"Wish I could talk it over with Dad once more."
```

The spirit of the text seemed to call for a relaxed, informal layout.

The one-word title "Daddy" was the obvious choice for the dominant element.

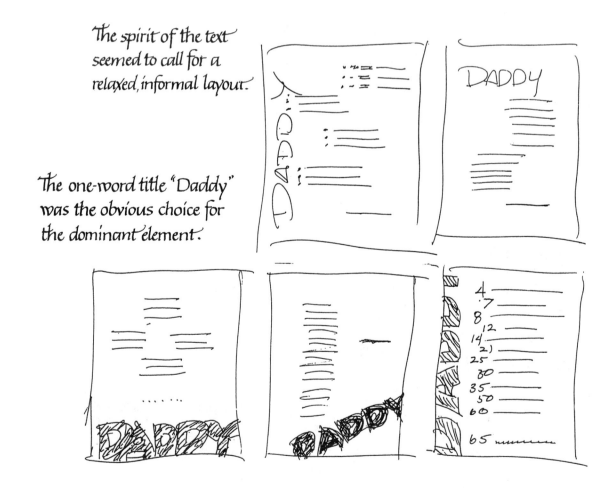

Layouts

The heart, drawn in gold,
was added as an after-
thought once the piece
was lettered.

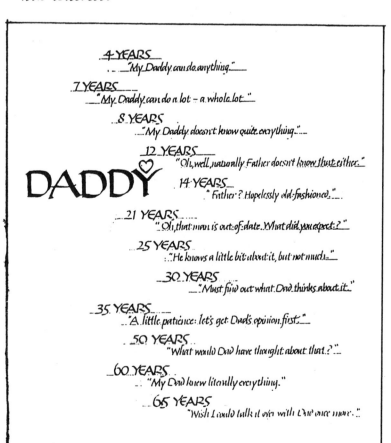

4 YEARS
..."My Daddy can do anything."

7 YEARS
"My Daddy can do a lot – a whole lot."

8 YEARS
..."My Daddy doesn't know quite everything."

12 YEARS
"Oh, well, naturally Father doesn't know that either."

14 YEARS
" Father? Hopelessly old-fashioned."

DADDY♡

21 YEARS
"Oh, that man is out-of-date. What did you expect? "

25 YEARS
..."He knows a little bit about it, but not much..."

30 YEARS
..."Must find out what Dad thinks about it."

35 YEARS
..."A little patience: let's get Dad's opinion first."

50 YEARS
"What would Dad have thought about that?"...

60 YEARS
... "My Dad knew literally everything."

65 YEARS
"Wish I could talk it over with Dad once more..."

Layouts

A proud mother requested that a poem composed
by her fifth-grader be lettered for framing.

The artichoke is round. It rolls away from me when I put it on
the table. It has spines on the leaves. The leaves are green,
squared. She runs away from me so I can't eat her with butter
and garlic. Rebecca Herreros, Grade Five, Kimberlin Elementary,
May 28, 1982.

The youth of the poet and
the jauntiness of the verse
dictated an informal layout.

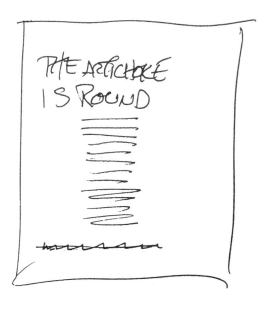

Emphasizing various words within the text.

Chose to combine the title with the opening words.

Dropping the leg of the "K" behind the copy tied the dominant title closer to the body of the poem.

The artichoke is round.
It rolls away from me
When I put it on the table.
It has spines on the leaves.
The leaves are green, squared.
She runs away from me
So I can't eat her with butter
and garlic.

May 25, 1982

REBECCA HERREROS
Grade Five
Kimberlin Elementary

Layouts

Rough layouts of a one-color
business card for a new
secretarial service.

Sometimes the customer will love the very first layout we show...

Spring 1983

NEW YORK WELLESLEY CLUB bulletin

5 East 64th Street · 10021 759-5120

Club gets brain

A VT-180 personal computer, complete with dot matrix printer, was generously donated to the Club by Digital Equipment. Lisa Hamm '79 has designed a data base for the computer and we will now have career, membership and billing information at our fingertips. Members will be able to learn to use the computer at future training sessions. We extend our heartfelt thanks to Digital, and a special thank you to Kerin Fenster, who brought about the donation.

Tennis, anyone?

Attend the finals of the Virginia Slims Championship at Madison Square Garden on Sunday, March 27, watch the top-seeded players in women's tennis, and help Wellesley go a long way towards completing its new Sports Center. Benefit tickets at $20, $30, or $50 are available through the Club.

Layouts

. . . and sometimes it seems as if nothing we do can satisfy our client.

```
Mira Karlovac, BSSA
Certified Public Accountant
1408 North Drive
Tampa, Florida  30330
(603) 552-8821
```

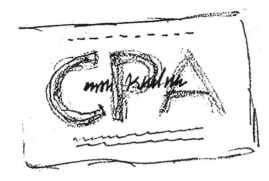

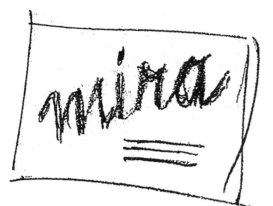

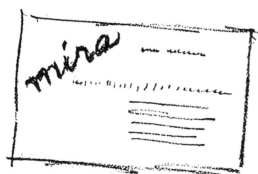

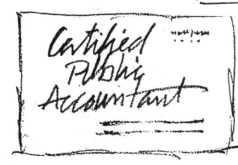

Layouts

You have seen the value of using thumbnails to develop your layout ideas. Occasionally, however, very rough sketches are less satisfactory than working directly with brush, marker or broad-edge pen. When developing a logo, for example, the choice of letterforms is sometimes a more important design consideration than is the format.

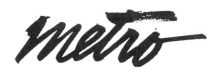

The customer went bankrupt before making a decision on a new logo. Unfortunately, these things happen.

Rough layouts exploring
another "wordmark" or logo.

U.S.Coachworks, Inc.

U.S Coachworks, Inc.

U.S.COACHWORKS, INC.

U.S Coachworks, Inc.

Layouts

The client, a realtor who favors gold accents,
wanted a sign to hang above her desk.

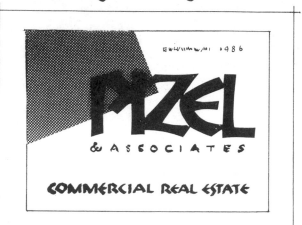

A dark blue "Pizel"
dominates the gold
background shape.

The name is gold-filled.

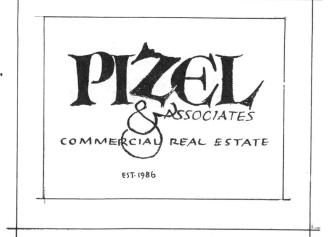

The tilted "z" is gold
in a dark red name.

40

Layouts

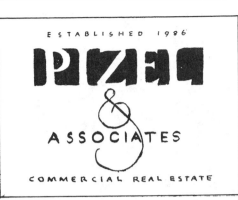

Name reversed out of a gold bar.

The "z" works well with the golden ampersand symbol.

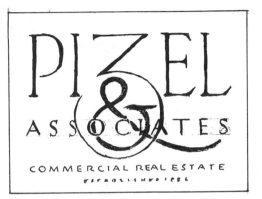

Trying "Associates" in gold.

The symbol made of abstract p's is gold.

This design was chosen.

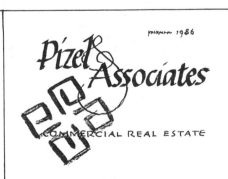

41

Layouts

By reversing the top words
out of black, we create the
dominant feature of this
company brochure cover.

A flourished script
which is carefully
drawn rather than
lettered with a nib.

Name reversed out of
bands of alternating
blue and green.

43

Layouts

Plano Chamber Orchestra

Name in blackletter with "Chamber" in contrasting red.

A round italic in blue, with green flourishes.

Plano Chamber Orchestra

44

Layouts

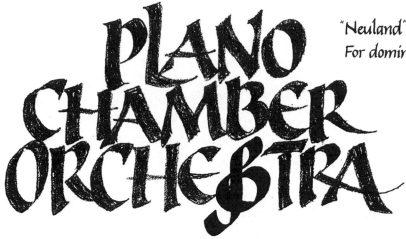

"Neuland" letters flush at top.
For dominance the text is centered below.

Casual roman caps in grey, the music staff in red for dominance.

A 2-color letterform, black strokes, blue shadow-lines.

PLANO
CHAMBER
ORCHESTRA

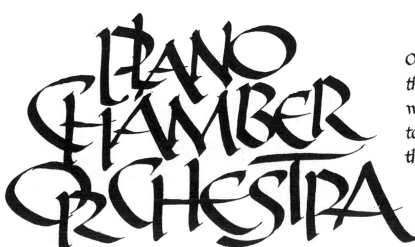

Overlapping letters; the top and bottom words are in color to contrast with the black "Chamber".

the customer selected the first idea.

45

Layouts

At times, the logo and the layout are inextricably linked, as in this design of a store business card.

Two words slanted in different directions, with vertical address line.

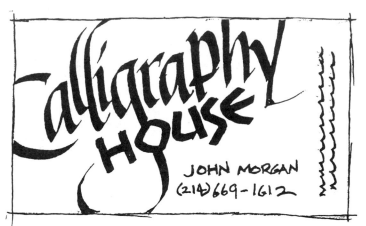

"Neuland"-style letters of equal size angled across card with text horizontal for contrast.

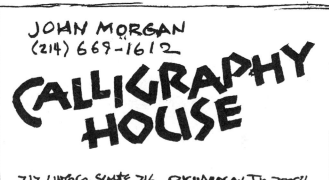

JOHN MORGAN
(214) 669-1612

JOHN MORGAN
(214) 669-1612

Same layout, with large
letters reversed out of a
color block.

Dominant letterforms slant across
the card, contrasting with and
separating the smaller text.

Layouts

SWN

southwest
newswire

SWnewswire

SOUTHWEST NEWSWIRE

Southwest
newswire

SWNewswire

SOUTHWEST newswire

The client wanted calligraphy in place of an
existing typeface, but didn't know exactly what
style. From these suggestions, the second and
third titles in the right-hand column were
selected for refining. (Not ones the designer
would have chosen, but...)

48

Layouts

Rather than using rough thumbnails to create a "Thank you" certificate, more detailed layouts were needed in seeking a successful combination of letterforms, balance, contrast and dominance.

 Trying it in a circle...

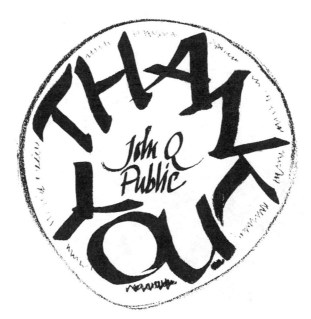

... in a narrow band...

49

Layouts

... and on a scrap of paper.

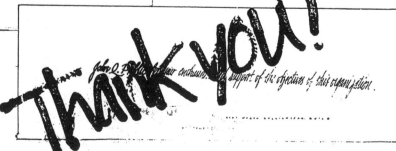

Multiple hand-scribbled "thank you"s flush at the top to contrast with the isolated bottom text.

Writing with a tube of paint for extra contrast.

Slanting the words off the edges of the area.

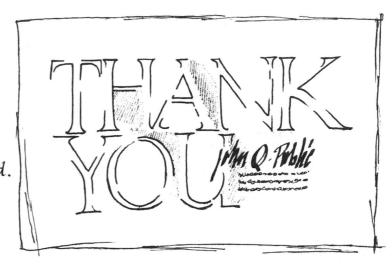

Text slightly overlaps
the "thank you" background.
Notice that the recipient's
name is now dominant.

Finally, a dominant title
lettered with an automatic
pen, the text tucked beneath.

Layouts

Once the alphabet styles and sizes, and any blocks
of text, have been roughed out, some designers then
scissor them apart and move the pieces around to
fine-tune the composition. Because time is money, this
is a more efficient method of refining a design than
constantly to reletter the elements in various positions.

Another way is to letter the elements on separate
sheets of tracing paper and then overlay the sheets,
shifting them around to reach a satisfactory
arrangement. The pages are then taped in position,
ready for the final calligraphy.

To center several lines of text on a piece of art, cut out
each line and fold it end-to-end to locate the center.
Then tape them in position with the folds lined up on
a vertical center line. This eliminates guesswork in
establishing line lengths. A printer can then use the
paste-up as camera-ready copy for reproducing the
artwork in quantity. Or it may be placed on a light-
table and copied over for a one-of-a-kind original.

Certificates
(One for the money)

Everyone enjoys receiving a certificate. It is tangible proof of a specific accomplishment and often is framed for display. The 3 main elements in any award are:

1) the event being recognized,
2) the donor of the award, and
3) the recipient or awardee.

It is up to the designer-client team to decide at the outset which element is to be dominant in the finished art. For instance, an award for heroism would stress the event itself,

OFFICE OF THE VICE PRESIDENT
THE WHITE HOUSE

Recognition of Courage

Presented to the people of Midland Texas in recognition of the outstanding performance by the people and City of Midland, which resulted in the rescue of Jessica McClure. The selfless and dedicated efforts of the Midland community represent the very best of the American spirit and have been an inspiration to all Americans

PRESENTED SUNDAY OCTOBER 18, 1987
MIDLAND TEXAS

GEORGE BUSH

Certificates

a graduation certificate might emphasize
the title of the course completed,

In this informal design,
the gold seal becomes
dominant due to the
contrast between the
bright gold foil and
the matte black copy.

and the recipient's name would
dominate a retirement resolution.

"Resolution" is lettered in
medium blue. Because
the recipient's name is
similar in size to the
heading, the name is
printed in black to be
the dominant element.

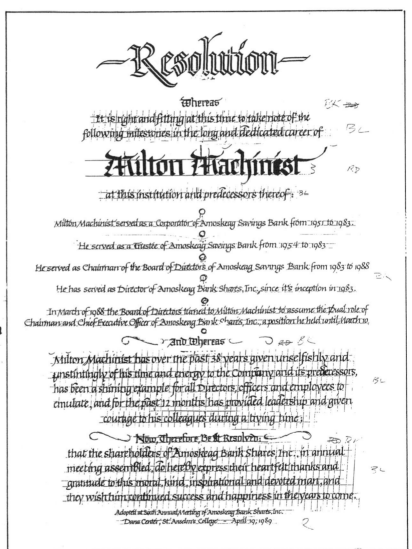

Certificates

In addition to establishing dominance, there are several other questions to be resolved which deal specifically with certificate design.

- Must space be allowed for signatures?
 - How many?
 - With what? (No ballpoints or rubber stamping)
 - Who is responsible for obtaining the signatures?

- Is the certificate to be dated?

- Must space be allowed for additional elements such as a logo, a ribbon, a seal or embossing?
 - Who supplies?
 - What colors are they?

- If the certificate is to be printed,
 - Will we charge extra for filling in names and dates or is the fee included in the budget?

• Is the framing included?

• With how many colors can we work? (Remember, the more colors used in a job, the higher the printing costs, and specially-mixed colors are more expensive than the standard inks.)

Most clients have a pretty good idea of how much they can spend on a job. In order for us to avoid (for instance) receiving only $100 for a $500 assignment, we must work within the budget. We must also keep our customer informed of any extra or unusual costs, such as die-cutting, and should not even suggest them if the budget cannot absorb the additional expense.

In this informal design, the gold seal becomes dominant due to the contrast between the bright gold foil and the matte black copy.

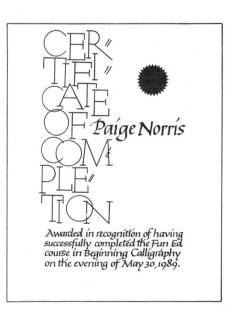

CER
TIFI
CATE
OF
COM
PLE
TION

Paige Norris

Awarded in recognition of having successfully completed the Fun Ed course in Beginning Calligraphy on the evening of May 30, 1989.

CREW
OUTSTANDING
ACHIEVEMENT
AWARD

1·9·8·6

COMMERCIAL REAL ESTATE WOMEN HONORS
MARTHA WATSON
FOR HER OUTSTANDING ACCOMPLISHMENTS
IN THE FIELD OF COMMERCIAL REAL ESTATE.

A deckled edge, obtained by tearing colored paper, adds interest to any award, whether used as a border

CREW
OUTSTANDING
ACHIEVEMENT
AWARD

1·9·8·6

COMMERCIAL REAL ESTATE WOMEN HONORS
MARTHA WATSON
FOR HER OUTSTANDING ACCOMPLISHMENTS
IN THE FIELD OF COMMERCIAL REAL ESTATE.

... or included within the certificate itself.

CERTIFICATE of ACHIEVEMENT

has completed all qualifications for the position of

FIELD TRAINER

including demonstration of the professional knowledge, skill and competence required to develop others who can meet the performance standards of TGI Friday's.

DIRECTOR OF TRAINING

DIVISION VICE PRESIDENT

_____ _____
DATE PRESIDENT

Reversing words out of a dark background can be an effective way of creating dominance.

Certificates

CERTIFICATE of
COMPLETION

THIS IS TO CERTIFY THAT

HAS SUCCESSFULLY COMPLETED
THE SURGIKOS COURSE IN

S U R G I K O S

This rough sketch stresses the use
of contrast in letterform and size,
dominance of the title and wide
white margins.

American Heart
Association

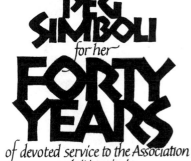

The American
Heart Association
gratefully recognizes

**PEG
SIMBOLI**
for her

**FORTY
YEARS**

of devoted service to the Association
and its mission

January 1949 - January 1989

The recipient's name and
the heart symbol were red.
"Forty years," cut from
gold foil, was spot-glued
onto the award, allowing
the letters to stand away
from the surface. Notice
the contrast with the text.

Certificates

For this formal award, the preprinted copy is
cut from light grey paper in a diamond shape
and centered on a dark blue background. The
dominant names are lettered in blue for
additional contrast with the black title and text.

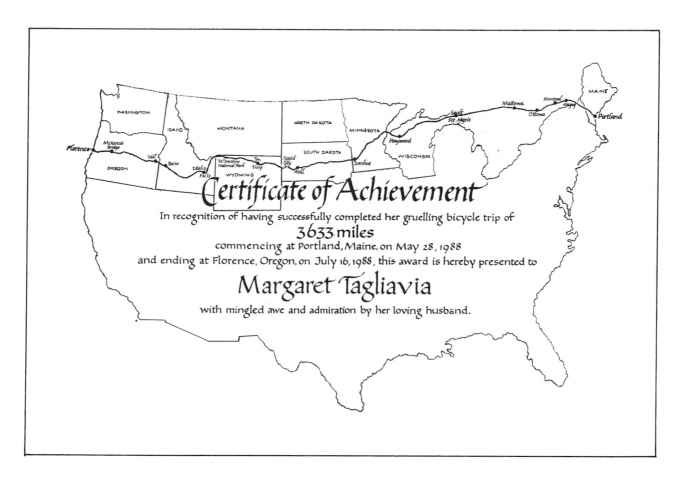

Certificate of Achievement

In recognition of having successfully completed her gruelling bicycle trip of

3633 miles

commencing at Portland, Maine, on May 28, 1988
and ending at Florence, Oregon, on July 16, 1988, this award is hereby presented to

Margaret Tagliavia

with mingled awe and admiration by her loving husband.

The map outline was blind-embossed, the state lines were debossed, to keep the route line (in red) unobscured. The mileage was also red, for dominance and to color-key the numbers to the route. Only the states traveled were titled, to ensure the legibility of the text beneath.

Certificates

Supportive Spouse A·W·A·R·D

"Two are better than one because
they have a good reward for their
labor. For if they fall, the one
will lift his fellow." ECCLESIASTES 4:9-10

_____ A. L. Williams Avellanet Region

The 2 initial S's are linked to symbolize marriage.

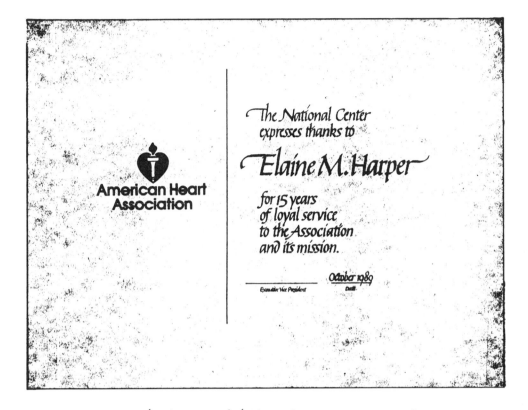

Only the heart symbol and numeral are red.
Client uses different background-paper colors
according to number of years served.
The logo dominates this layout because of
its isolation, it's compact design and the
red heart. The recipient's name is in the
same (black) italic as the text to keep the
name subordinate to the logo.

Certificates

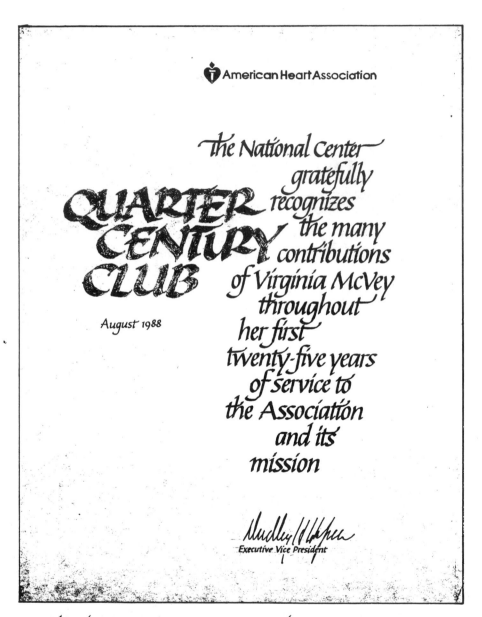

The dominant letters are gold, the symbolic heart and "twenty-five years" are red, providing an effective contrast with the rest of the copy.

RICHARDSON CHAMBER OF COMMERCE

DATE

CHAMBER CHAIRMAN OF THE BOARD

"Certificate of Appreciation" is printed in light blue on gray stock, allowing the black copy to pop out. Because we read the tops of letters, the smaller words were placed low (instead of centered) over the larger to aid legibility.

Certificates

This certificate is awarded in recognition of having successfully completed the Basic Layout and Design for Calligraphy course to

rosemary gissler

in the cheerful expectation that in the years to come, the world will be markedly enriched by this graduate's contributions to the creation of a more beautiful visual environment.

Alan W. Furber

A genuine turkey feather was glued onto each certificate, creating dominance. The text was preprinted and finally each name was shoehorned into the space.

Each calligraphy class receives a different award.
Designing a brand-new certificate each month is
an enjoyable task, thanks to the copy machine.

Certificates

Gail
Vaughn-
Dunn

This Certificate of Appreciation
is hereby awarded in recognition of
having successfully completed the
Fun Ed course in Beginning Calligraphy
on the evening of June 26, 1990.

The dominance of the name
was enhanced by surrounding
it with lots of empty space,
isolating it.

The text is printed on torn brown
Kraft paper, which is then mounted
on a cream-colored background
with a strip of double-faced tape,
only at the top, allowing the Kraft
to hang loose. This adds an extra
interest to the certificate. The name,
in red, dominates through isolation.

Certificates

This certificate is hereby awarded to

Cynthia Thomas

in recognition of having successfully
completed the Fun Ed course entitled
'Beginning Calligraphy' on the cool
winter evening of February Twenty,
Nineteen Hundred and Ninety-One.

INSTRUCTOR

Using clip art, gold notary seal and
colored ribbon. Though the figure
pulls the eye up away from the text,
the ribbons counteract by nailing it
to the design.

72

Certificates

Notice how the signature placement restores balance to the layout.

Certificates

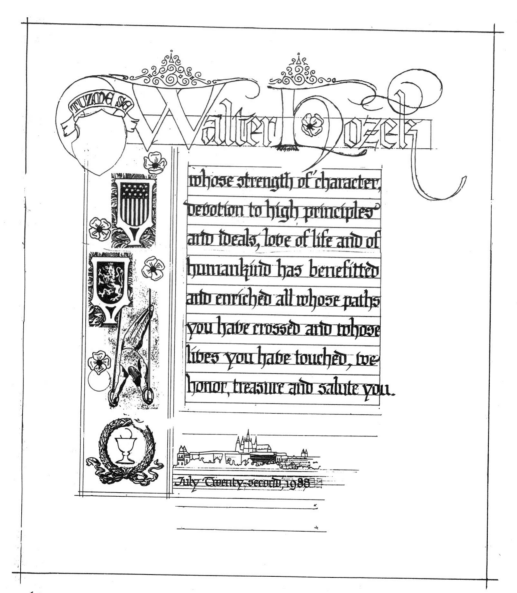

whose strength of character, devotion to high principles and ideals, love of life and of humankind has benefitted and enriched all whose paths you have crossed and whose lives you have touched, we honor, treasure and salute you.

Walter Dozer

July Twenty-second, 1988

The customer requested the inclusion of many different items, yet the name remains dominant due to its size, style and gold-filled letterforms. Not shown is a blind-embossed eagle in the lower right-hand corner.

74

His Excellency the President of the Republic of The Gambia
Alhaji Sir Dawda Kairaba Jawara
requests the pleasure of your company at dinner
on Saturday, April 7, 1990
The Adolphus

7:30 p.m. Cocktails
Mezzanine Level

8:00 p.m. Dinner
Pat Morris Neff Room

Valet Parking Regrets Only
1321 Commerce Street (214) 943-2771

An invitation can be formal (to a function) or
informal (to a party). It's up to us to elicit from
our client the information necessary to make the
correct choice.

Social

Most wedding invitations are formal. They are also boring, for many brides hesitate to be adventurous in their nuptial preparations. The designer, however, may suggest making the names of the bride and groom the dominant elements by means of a change in letter style, size or color.

Mr. & Mrs. H.B. Battle
request the honour of your presence
at the marriage of their daughter

Joyce M. Giddens
to

Mr. Arcasano Steadham

on Saturday, the twenty-sixth of March
nineteen hundred and eighty-three
at three o'clock in the afternoon

Sims Chapel Baptist Church
317 Parker Drive
Garland

If you are unable to attend,
we request your presence in prayer.

Once in a while we will meet a client who is seeking something out of the ordinary, and such a time designing a wedding invitation can be a lot of fun.

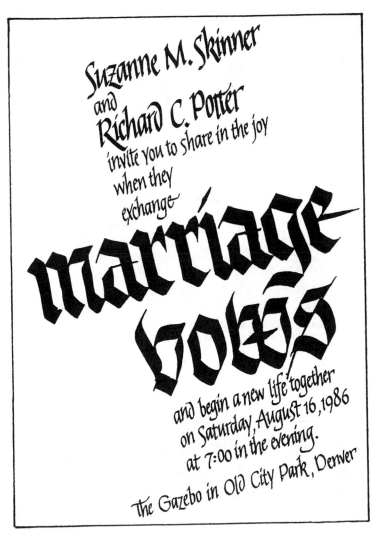

Social

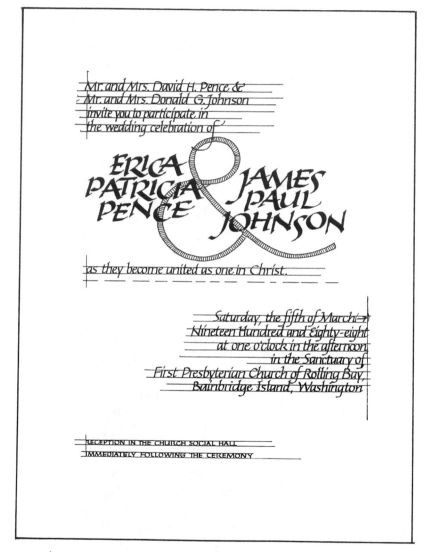

Mr. and Mrs. David H. Pence &
Mr. and Mrs. Donald G. Johnson
invite you to participate in
the wedding celebration of

ERICA PATRICIA PENCE & **JAMES PAUL JOHNSON**

as they become united as one in Christ.

Saturday, the fifth of March
Nineteen Hundred and Eighty-eight
at one o'clock in the afternoon
in the Sanctuary of
First Presbyterian Church of Rolling Bay,
Bainbridge Island, Washington

RECEPTION IN THE CHURCH SOCIAL HALL
IMMEDIATELY FOLLOWING THE CEREMONY

On the printed invitation, the ampersand
was screened to a light grey, leaving the
large names as the dominant element.

By the very nature of the event, party invitations, except for the stuffier occasions, allow us the leeway to be more inventive than usual, to break away from the staid. Bright colors, textured paper, bouncing letters — all can enliven the happening.

Bill Flannery and Sue Kelly
announce the formation of
An INVESTASEARCH, INC.
Invitation and invite you to help us
mark the occasion with
an enchanting sunset trail ride
at the Circle R Ranch.

Friday, October 28, 1983
6:15 p.m.

RSVP / 238-5348

Social

RANDY LEVERETT is relocating his office to KKP Printing and Office Supply at 8111 Las Vegas Freeway, Suite 155, Lake Mead, Nevada 89110 (432) 198-7655

An announcement, like any design, requires balance, contrast and dominance.

JOHNSON, McELROY, JOHNSON & SMITH

is pleased to announce that

Steven Wm. Buholz

and

Randall Duke

have joined the firm as partners
and that the firm name has been changed to

JOHNSON & McELROY

NCNB PARK CITIES BUILDING
Preston at Mockingbird
5500 Preston Road, Suite 370
Dallas, Texas 75205
(214) 521-6300

(If there isn't such a word to describe a fifth anniversary, there should be.)

First Quintennial Reunion
AND DINNER DANCE

Posters

Posters, usually seen from a distance, need to be eye-catching to draw the viewer close enough to read the details. This old poster is an excellent example of the power of brevity, delivering the message quickly and succinctly.

The animal was traced from a color photo.
Its eyes and the headline are printed in
orange for interest as well as for dominance.

Even when read from a distance, a poster should deliver its primary message.

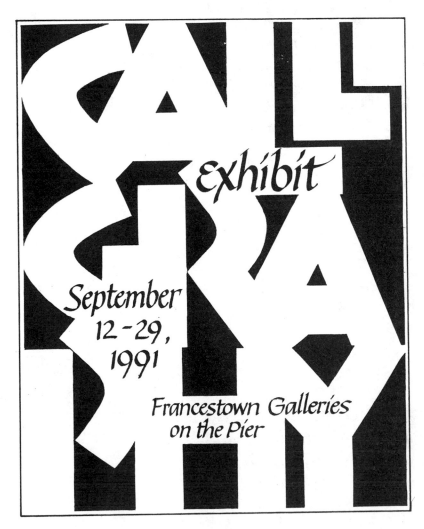

Once in a while, a poster will make
sense to no one but the customer.'

The Dallas Morning News "First Weekend" Series at the Dallas Zoo
Presents

AFRICAN HERI·TAGE FESTIVAL

SATURDAY, APRIL 1 & SUNDAY, APRIL 2
1-5 P.M.

LAINI KUUMBA NGOMA
Dance Troupe from Houston, performing traditional rhythmic music and dance from different African countries.

FACEPAINTERS

STILT WALKER

DALLAS BLACK DANCE ACADEMY

STORYTELLERS

AFRICAN CRAFTS
Demonstrations and Participation Activities for All Ages:
· Batik block printing
· T-Shirt screening (bring your own T-shirt)
· Animal construction
· Mask making
Ceramics · Weaving

ALL **FREE**, WITH ZOO ADMISSION :
$3.00 for adults, $1.50 for children 6-11 and seniors over 55
(Free for kids under 6.)

DALLAS ZOO · 621 CLARENDON · 3 MILES SO. OF DOWNTOWN · TAKE EWING EXIT OFF I-35

SPONSORED BY: The Dallas Morning News · K104 fm · Frito Lay

A contrasting color does not guarantee dominance. Although "Festival" is printed in red, its inline letter style subordinates it to the solid black words directly above.

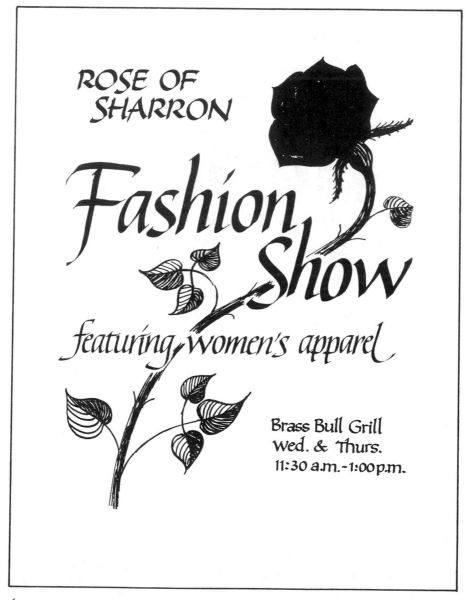

The red rose dominates this informal layout.

Sometimes a rectangular design can be framed
within a circle for additional interest.

Posters

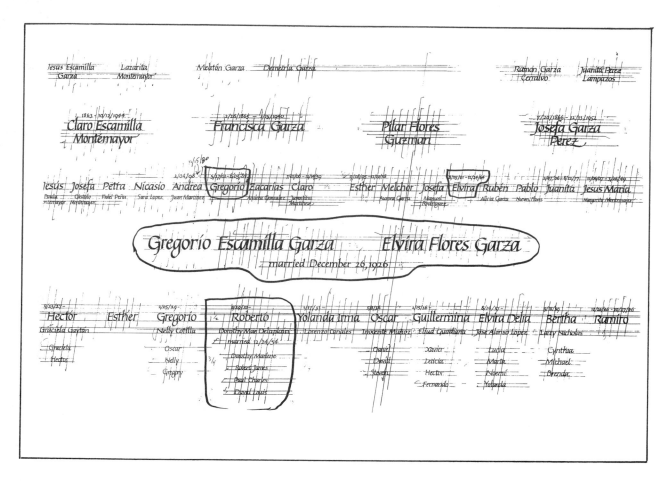

A family tree without the
customary lines of descent.

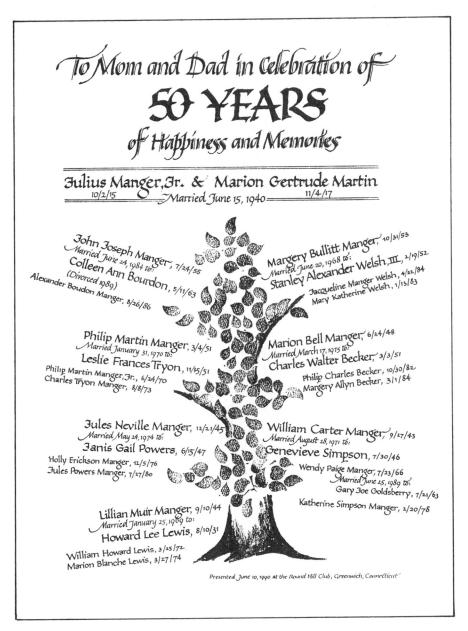

A literal interpretation of "family tree." The leaves are rubber-stamped in green, the trunk is in gold gouache.

Posters

Cadet Prayer

Oh God, our Father,

Thou Searcher of men's hearts, help us to draw near to thee in sincerity and truth.
May our religion be filled with gladness and may our worship of Thee be natural.

Strengthen

and increase our admiration for honest dealing and clean thinking,
and suffer not our hatred of hypocrisy and pretense ever to diminish.

Encourage

us in our endeavor to live above the common level of life.

Make

us choose the harder right instead of the easier wrong,
and never to be content with a half truth when the whole can be won.

Endow

us with the courage that is born of loyalty to all that is noble and worthy,
that scorns to compromise with vice and injustice
and knows no fear when truth and right are in jeopardy.

Guard

us against flippancy and irreverence in the sacred things in life.

Grant

us new ties of friendship and new opportunities of service.

Kindle

our hearts in fellowship with those of a cheerful countenance
and soften our hearts with sympathy for those who sorrow and suffer.

Help

us to maintain the honor of the Corps untarnished and unsullied,
and to show forth in our lives the ideals of West Point
in doing our duty to Thee and to our country.

All of which we ask in the name of the Great Friend and Master of men.

Amen.

The title and the subheads are in blue, the ruled
lines and the helmet are in silver tempera and the
text is in black — all on a "West Point Grey" paper.

Poetry

When we are asked to letter a favorite poem or prayer, the layout is usually left to our design discretion. A scriptural verse is most often laid out in a formal format, echoing the solemnity of the subject matter.

This formal layout was rejected because the time required to custom-fit the text exceeded the budget. (Another example of a $500 job for a $100 fee.)

The Lord
IS MY
Shepherd;

I shall not want. He maketh me to lie down in green pastures; He leadeth me beside the still waters. He restoreth my soul. He leadeth me in the paths of right-eousness for His name's sake. Yea, though I walk through the Valley of the Shadow of Death, I shall

Death, I shall fear
no evil, for Thou
art with me; Thy
rod and thy staff
they comfort me;
Thou preparest a
table before me in
the presence of
mine enemies; thou
anointest my head
with oil, my cup
runneth over.

Surely goodness
and mercy shall
follow me all the
days of my life,
and I will dwell
in the house of
the Lord forever.

Amen.

I shall not want;
He maketh me to lie down in green pastures
He leadeth me beside the still waters
He restoreth my soul;
He leadeth me in the
paths of righteousness
for his name's sake.

THE LORD IS
MY SHEPHERD;

Yea, though I walk through the valley of
death, I shall fear no evil;
for thou art with me
Thy rod and thy staff, they comfort me.
Thou preparest a table before me in the presence
of mine enemies;
Thou anointest my head with oil,
my cup runneth over.

Surely, goodness and mercy
shall follow me all the days of my life; and
I shall dwell in the House of the Lord
forever.

THE TWENTY-THIRD PSALM

This informal layout was the client's choice. (So much for "solemnity"!)

Poetry

Little Lamb

Little lamb, who made thee?
Dost thou know who made thee?
Gave thee life, and bid thee feed
By the stream and o'er the mead;
Gave thee clothing of delight,
Softest clothing, wooly, bright;
Gave thee such a tender voice,
Making all the vales rejoice?
Little lamb, who made thee?
Dost thou know who made thee?

Little lamb, I'll tell thee,
Little lamb, I'll tell thee;
He is called by thy name,
For He calls himself a lamb.
He is meek, and He is mild;
He became a little child.
I a child, and thou a lamb,
We are called by His name.
Little lamb, God bless thee!
Little lamb, God bless thee!

William Blake

Sometimes, a barely dominant title can be strengthened by lettering it in a contrasting color. The freehand border was drawn with the same lettering nib to complement the text.

Calligraphy by Constance Chadwick Kean

HELP WANTED

A LAW FIRM commanding
Position of standing
Requires a general clerk—
A man who's committed
To practice, and fitted
To handle diversified work;

Must know the proceedings
Relating to pleadings,
The ways of preparing a brief;
Must argue with unction
For writs of injunction
As well as for legal relief.

Must form corporations
And hold consultations
Assuming a dignified mien;
Should read each decision
And legal provision
Wherever the same may be seen.

Must analyze cases
And get at their basis,
Should never be idle or slow;
Must manifest learning
In all things concerning
The matters referred to below:

Attachments and trials,
Specific denials,
Demurrers, replies and complaints,
Disbursements, expenses
And partial defenses,
Ejectments, replevins, distraints;

Estoppels, restrictions,
Constructive evictions,
Agreements implied and express,
Accountings, partitions,
Estates and commissions,
Incumbrances, fraud and duress.

Above are essentials,
The best of credentials
Required—and handsome physique;
Make prompt application,
Will pay compensation
Of seventeen dollars a week.

FRANKLIN WALDHEIM

With so much text, this formal design could have been laid out in 2 rows (see next page), but the client preferred a 1-column arrangement.

Poetry

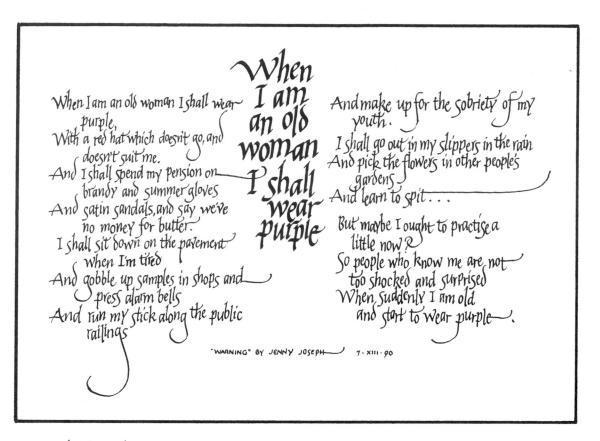

When I am an old woman I shall wear purple,
With a red hat which doesn't go, and doesn't suit me.
And I shall spend my pension on brandy and summer gloves
And satin sandals, and say we've no money for butter.
I shall sit down on the pavement when I'm tired
And gobble up samples in shops and press alarm bells
And run my stick along the public railings

When
I am
an old
woman
I shall
wear
purple

And make up for the sobriety of my youth.
I shall go out in my slippers in the rain
And pick the flowers in other people's gardens
And learn to spit . . .

But maybe I ought to practise a little now?
So people who know me are not too shocked and surprised
When suddenly I am old and start to wear purple.

"WARNING" BY JENNY JOSEPH 7 · XIII · 90

The large letters, a repeat of the poem's
first line and selected to be the title
for added interest, are purple - as is
the credit line. The text is bright red.

Bouncing the letters reflects the
breeziness of the verses.

This piece was done as a gift
for friends.

Sixty years have come and gone,
 with sixty more to go,
From Nauset Beach and Pleasant Pond
 and learning how to row,
To getting up before the dawn
 and starting off real slow.

How memories keep crowding in,
 The sights and sounds and smells
Of chasing spooks in East Berlin
 and newborn daughters' yells,
Of tête-a-têtes with Banjo Win
 and littered lobster shells.

And then, Gamaliel Painter's cane,
 and sodas at The Hollow,
And Mr. 'Ashcan' (what a pain)
 and brothers, two, to follow;
A rocking horse with painted mane
 (So high! T'was hard to swallow.)

Remember Southworth holding forth
 in Frothingham that day?
And, every summer, heading North,
 and Uncle Levi's hay,
And firecrackers on the Fourth
 and "What does Rexie say?".

One could go on and on this way,
 unearthing scenes long past;
But since you get the point, I'll say,
 "The years go by so fast;
Enjoy your special Natal Day!"

(Six decades? I'm aghast!)

[signature]

The handwritten signature helps
to anchor the layout.

Poetry

The gold
flourishing
behind the
blue title
adds a bit
of class
without
obscuring
legibility.

Ode to Ambassador Winslow

On the occasion of his visit to the London Zoo, August 27, 1989

You've heard of the case,
　The lack of space
　　For tuatara

The which, apace,
　Might lose the race
　　Into tomorra;

Then from New Zealand
　With its verdant hills and view
Were highly honored
　In London and the Zoo.

There came a man
　To help us plan
　　For tuas' better prospects,

From kiwi land
　Let's greet the Grand.
　　Ambassador Sir Alex.

BY CHARLES ROSE

Adding Type

There are times when it is not only feasible, but preferable to combine calligraphy with typeset. For instance, a business letterhead may require the listing of several branch offices, phone numbers or executives, and hand-lettering them can cost more in hours than the budget will allow.

```
Sometimes a clean and uncluttered typeface
            offers a welcome visual respite
        within a large amount of calligraphy.
```

Printers are a reliable source of typefaces and usually can supply a listing of the styles they have available.

Also, there are companies which specialize in setting type to order, with a selection of styles running into the thousands.

The desktop publisher is still another supplier of type, generated by computer.

A fourth option is to buy sheets of transfer type from an art store. With this "do-it-yourself" material, the designer has a wide choice of styles and sizes. Because each word is applied letter-by-letter, this method could be too time-consuming to be economical on a full page of text.

Adding Type

Designers can also buy alphabets of rubber stamps, and stencils, though rarely would these be used for any lengthy amount of copy.

Because the term "calligraphy" covers a broad spectrum of letter styles, there are a few guide-lines to be aware of when combining lettering with typefaces.

KUDOS COLLEGE

Founded June 13, 1948

by the

DALLAS ADVERTISING LEAGUE

THIS DIPLOMA WITNESSETH THAT

Thomas R. Sandoz

For extraordinary and dedicated service to the Dallas Advertising League – having served as President thereof during the 1985 - 1987 term...and in continuing honor of the

75th ANNIVERSARY

of the League...is hereby named

PRESIDENT OF KUDOS COLLEGE

with all the rights and privileges of that office.

In Witness thereof this certificate is signed for presentation _____ .

DALLAS ADVERTISING LEAGUE BOARD OF REGENTS, KUDOS COLLEGE

_____ _____
PRESIDENT CHAIRMAN

Try to use only 2 contrasting letterforms within a single design, varying their size and weight to achieve balance.

Adding Type

It's possible to blend several alphabets within a single layout, but the result is often less pleasing than limiting the selection. In this example, the client wanted a variety of styles on a menu.

Adding Type

Work with contrasting styles, not similar ones.
A vertical roman with a slanting italic . . .

The Service you expect

At BSC, we believe our company is best promoted by building goodwill and lasting relationships with our customers. This "word-of-mouth" advertising has proven very successful for us. The secret to keeping and attracting customers can be stated in one simple word. Service.

At BSC, we know a good product line is only as important as the people who service it. That's why we take great pride in having a tremendous service record.

We strive to respond to customer inquiries in 24 hours or less. Our sophisticated computerized claims payment system pays a claim every four minutes. And we usually settle most claims in just 10 days. This kind of fast customer response is proof positive that BSC is dedicated to serving their needs.

To maintain our excellence, we take great care in selecting and training the best people for staff personnel and independent agents. We develop the skills of people who enjoy helping others. People who know the difference personal service makes.

All of our efforts are for one purpose: To ensure that, no matter with whom you deal at BSC Life Insurance Company, you'll enjoy the quality of service and expertise that sets us apart as the "personally better" insurance company.

By providing the best possible products and service for our customers, we believe our success is ensured.

... rather than 2 related vertical letter styles.

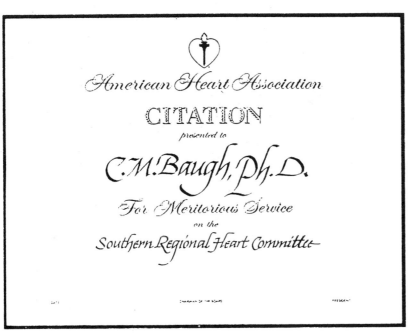

This is the unhappy result of mimicking a printed cursive letter with calligraphy.

A more effective solution is to use a contrasting letter style.

BEAUTY
EMPORIUM
In harmony with Nature

Transfer type with calligraphic accents.
Leaf symbol is green.

Adding Type

: A decorative initial or word will complement a sturdy, gothic-style text.

Adding Type

Brush lettering, casual and loose in appearance, can be a pleasing counterpoint to a stiff, mechanically perfect typestyle.

motor
graphics

custom pinstriping,
repair and replacement

custom trim accessories

chrome fenderwell moldings,
door edge guards, mirror backs

sam armstrong
214·792·2914

p.o. box 586397
dallas, tx. 75258

Adding Type

Even typewritten copy can effectively be juxtaposed with hand lettering.

THE BOSTON HERALD-TRAVELER

"FIRST WEEKEND" SERIES AT

THE FRANKLIN PARK ZOO

Presents

JAZZ WEEKEND

Saturday, March 4, noon to 5 P.M.
Sunday, March 5, 1 to 5 P.M.

Dorchester Jazz Orchestra
University of Massachusetts
One O'Clock Lab Bank
Arts Magnet High School Jazz Combo
Alexander's Ragtime Band
Bart Marantz Jazz Quintet

Franklin Park Zoo
621 East Clarendon Drive
Just 3 miles south of downtown off I-35--
Take Ewing Avenue Exit

Free with zoo admission, which is $3.00
for adults, $1.50 for children 6-11 and
seniors 55 and over, and free for children
5 and under.

Sponsored by:

The Boston Herald-Traveler *and* Jazzy. 99.1

105

Adding Type

When a headline must dominate, a strong, blocky letter can be balanced by a lighter one.

HAKAN'S *Salon*
Management
System

- Inventory Control
- Client Information
- Daily Operations Aid
- Operations Analysis
- Bio-Rhythm
- Automatic Log Function
- Cumulative Operations Analysis
- and more ...

Hakan's Salon Management System is a comprehensive set of computer programs for the efficient, cost-effective management of hair salons. Designed by Hakan Gul, a successful North Dallas hair designer and salon owner, this system is implemented by AMT computer consultants in a high-level computer language. The system took over three years to design and develop and is currently operational at the Hair Chateau in Preston Royal Shopping Center, a prestigious North Dallas location.

Adding Type

In addition to enlivening a page of type with calligraphic accents, it's also possible to anchor a piece of calligraphy with a touch of typography.

Womanfriend
You touch my soul.
You hear my pain
And it does not frighten you.
My tears flow,
Filling both of us
Like swift torrents of Spring.
You affirm my spirit!
We rise with the joy
Of new awakening.
Womanfriend,
I embrace you
As we exchange
Our energy.

With thanks for your generous gift to

The Edith Bixby Center
for the Protection of Women

Adding Type

Sometimes the assignment is to letter on a printed document, such as a birth certificate or a family tree, and the calligraphy should complement rather than mirror the typeset copy.

For example, "Foundational" would contrast effectively with a flowing cursive, and a slanted italic would be an appropriate choice to accompany a gothic-style typeface. The designer considers the style, slant, size and weight of letters when arriving at a decision.

Questions

MANAGEMENT
DEVELOPMENT *DRESSER*

awards this certificate to

in recognition of successful completion of the

Executive Development Program

Date

Chairman & Chief Executive Officer

President

Senior Vice President-Human Resources

Director Management Development

In order to do our best for the client, it is extremely important that we understand all the requirements of a job before beginning the thumbnail sketches.

Last-minute changes by the client can wreak havoc with a design. While sometimes revisions are unavoidable, often they're due to poor communications.

The questions we ask will vary, depending on the assignment, but the following queries will apply to most design jobs.

Questions

• Is the assignment one-of-a-kind, or will
 it be printed in quantity?
 ~Who is responsible for getting it printed?

• What will be the size of the printed art?

• On what material will the work be done?
 (Paper, vellum, glass, cloth … ?)
 — Who supplies the material?

• How many colors can be used?

• Will the completed piece be framed? Matted?
 ~Who is responsible for getting it done?

• When is the original art due? The printed art?
 ~Does the designer deliver the finished
 work or will the customer pick it up?

Questions

By obtaining answers to these questions, not only do
we establish our credentials as professionals — we
encourage the client to think specifically about
what is involved in the assignment.

Two more questions remain to be asked,
which only we, as designers, can answer;

- Is a formal, symmetrical layout more
 appropriate to the subject matter than
 an informal one?

- Should the format be horizontal ...

Questions

... or vertical ?

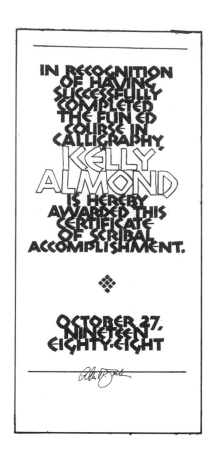

(The answer to the first question will depend upon the occasion being observed. The second query, usually, can be dealt with by determining the amount of text to be lettered. As a rough guide, if there's a lot of copy involved, a vertical format may be preferable because shorter lines are easier to read.)

Envelopes
(Two for the show)

In the world of envelope decoration, postal employees are our best friends — and toughest critics. For if our creativity is to amuse or astonish the addressee, the envelope must be delivered — and that means that the forward and return addresses must be legible. Other than legibility, however, there are few restrictions on what we can do to the surface of an envelope. In fact, much of the enjoyment in ornamenting mail comes from the opportunity to create, free of the limitations inherent in a commercial assignment.

We can wrap the recipient's name around the edges of the envelope or write it upside-down, partially obscure it or leave it off altogether, write it huge or write it tiny, tilt it or twist it or paste it on with cut-out letters.

We can illustrate the envelope, spill ink on it, glue on stars or sequins, rubber-stamp it, marbleize it, or pass it through a copy machine.

Envelopes

We can even make our own envelopes from gift-wrap, newspapers, magazines or shopping bags. As long as the address is clear and the stamp is clean, we can create works of art that the addressee will enjoy receiving, displaying and saving.

Some of the following examples are simple and some are elaborate, but notice: all are clearly addressed. So enjoy studying these flights of postal fancy, then let your own creative talents begin to kick in. There are literally scores of ways to jazz up correspondence.

A gift from a friend.

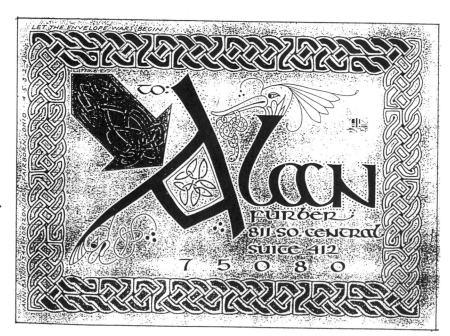

114

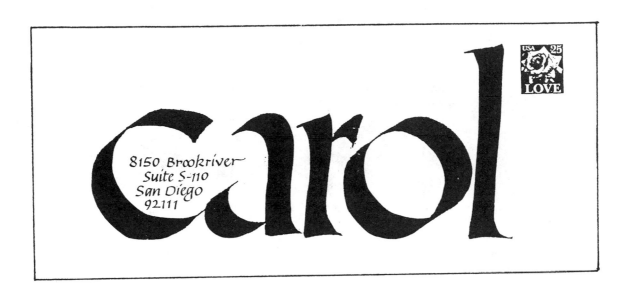

8150 Brookriver
Suite S-110
San Diego
92111

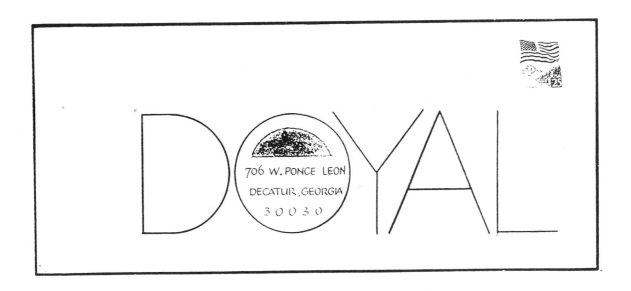

706 W. PONCE LEON
DECATUR, GEORGIA
30030

Addresses within the names.

Envelopes

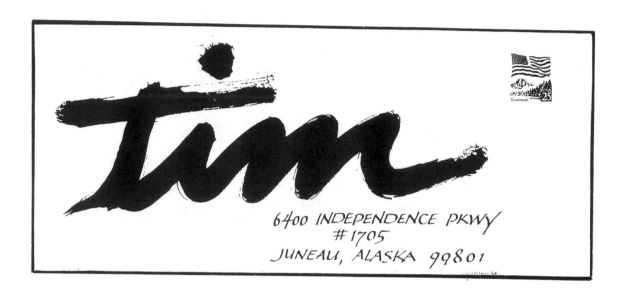

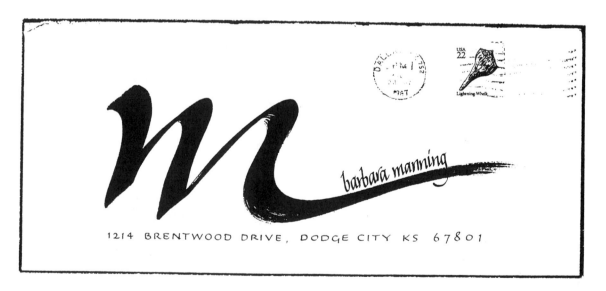

The dominance of brushstrokes.

"Neuland" can be effectively dominant, also.

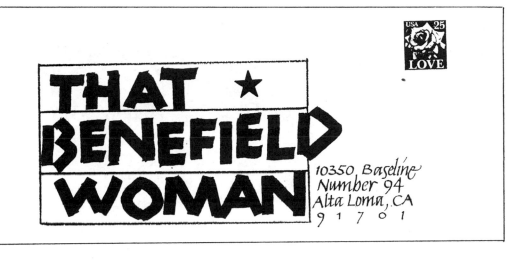

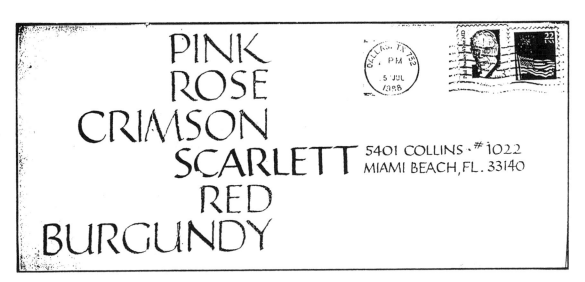

Six different reds brightened her day.

Envelopes

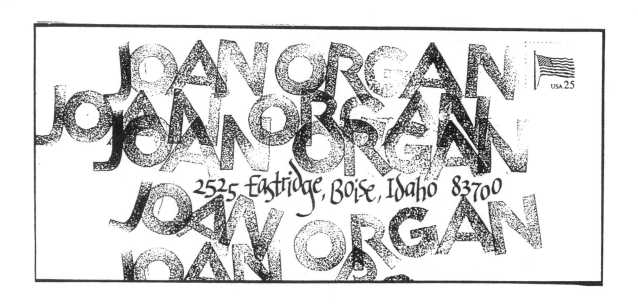

Rubber-stamping names, whole or in part.

Envelopes

Mrs. Diane Hammill, Quilter
125 Puritan Ave.
Quincy, Illinois
6 0 6 0 6

The picture of the addressee was enlarged
from a 1944 high school yearbook and
photocopied onto the envelope.

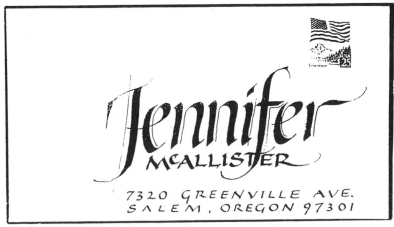

An example of simple contrast and dominance.

Envelopes

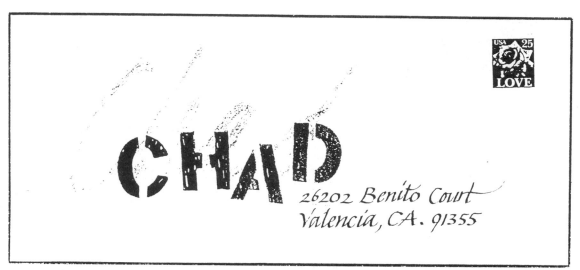

Stencilling over a name brush-lettered
with (very) dirty paint water.

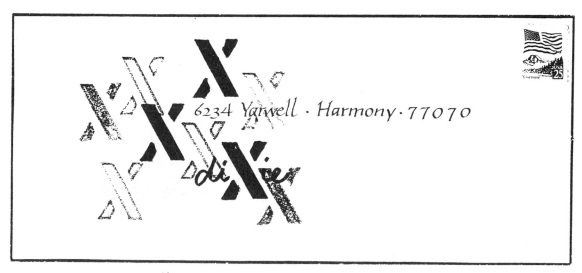

Using simple stencilled letters.

To ensure delivery, the address is in dark red,
contrasting with the pink copy above it.'

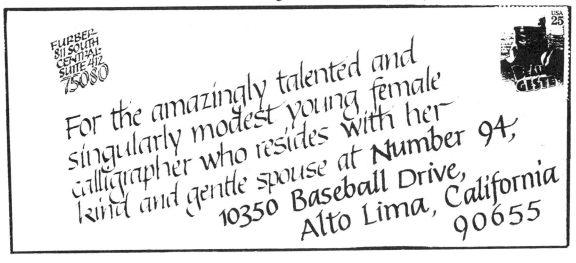

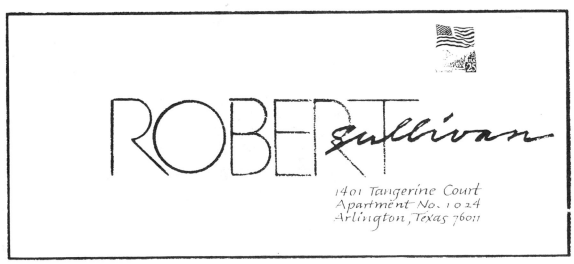

A circle guide was useful in preparing this envelope.

Envelopes

Half-a-dozen colored markers,
bound with a rubber band,
functioned as a single tool.

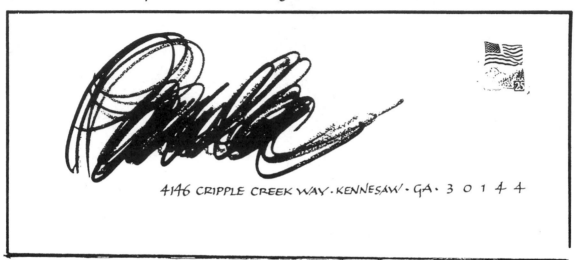

4146 CRIPPLE CREEK WAY · KENNESAW · GA · 3 0 1 4 4

D E B R A

12221 MERIT DRIVE, SUITE 160, NEWTON 0 5 2 5 1

Using letters cut from a magazine.

A single comma, cut from a plastic
eraser, created this effect.

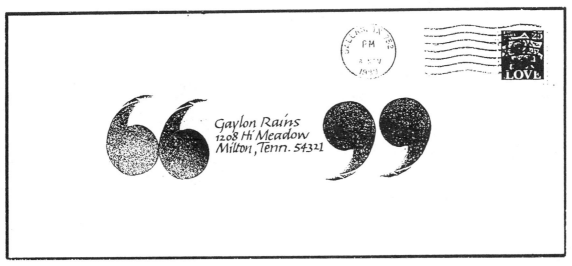

Gaylon Rains
1208 Hi Meadow
Milton, Tenn. 54321

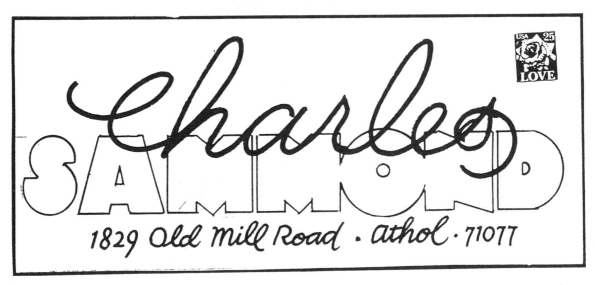

1829 Old Mill Road · Athol · 71077

The outline letters could be cut from a single color
photograph (a seashore or mountain range, for
instance) for additional drama.

Envelopes

Mr Ron Parsons
Department of Design
Earl Richards Road North
Exeter EX2 6AS, U.K.

Dear Mr. Parsons:

First, the typewritten letter to be enclosed in this
envelope was copy-enlarged. The result was torn,
leaving only the heading and the salutation.
This was pasted onto the manila mailer, then
brightened by striping with a yellow hi-liter.

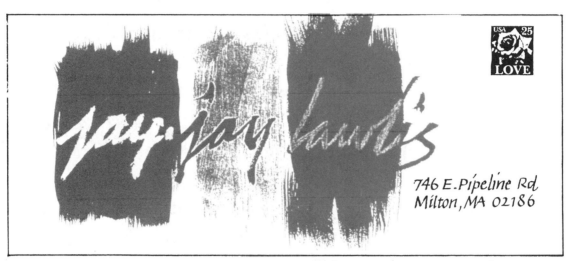

Splashing colors over other colors
for a cheerful effect.

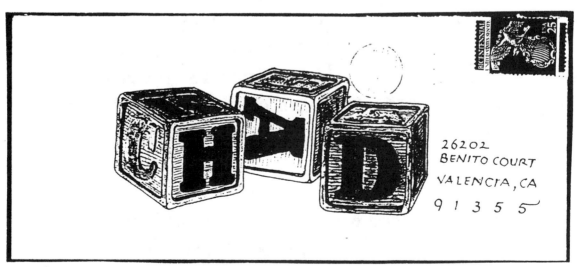

Outlined with a pointed pen
and filled in with colored markers.

Conclusion

Learning to letter a difficult alphabet such as roman capitals takes patience, perseverance and a developing musculature. We follow a steep and tortuous trail up the mountainside, yet the peak is always in view, a specific goal which can be reached if we just keep climbing.

On the other hand, designing a layout is akin to exploring unmapped territory. No crest beckons us, no perfect "R" awaits our efforts. We are venturing into the unknown, and it can be scary.

One way to design is to copy slavishly an existing layout: the way we copy letterforms. That way we remain on familiar ground, taking no chances. The other way is to struggle through to our own design solution, which is harder to do – and far more satisfying in terms of a personal accomplishment.

There is nothing wrong with copying the layouts in this book. Using these suggestions, however, as a way to develop your originality will toughen your design muscles enough for you to reach your own artistic mountaintop.

Index

127